Joint Forms and Muscular Functions

Michel Lauricella

MORPHO

anatomy for artists

T0160080

rockynook

Morpho: Joint Forms and Muscular Functions: Anatomy for Artists
Michel Lauricella

Editor: Joan Dixon
Project manager: Lisa Brazieal
Marketing coordinator: Mercedes Murray
Graphic design and layout: monsieurgerard.com
Layout production: Hespenheide Design

ISBN: 978-1-68198-540-4
1st Edition (3rd printing, July 2022)

Original French title: Morpho: Formes Articulaires Fonctions Musculaires
© 2019 Groupe Eyrolles, Paris France
Translation copyright © 2019 Rocky Nook, Inc.
All illustrations are by the author.

Rocky Nook, Inc.
1010 B Street, Suite 350
San Rafael, CA 94901
USA
www.rockynook.com

Distributed in the UK and Europe by Publishers Group UK
Distributed in the U.S. and all other territories by Ingram Publisher Services

Library of Congress Control Number: 2019940042

This book is printed on acid-free paper.
Printed in China

Publisher's note: This book features an "exposed" binding style. This is intentional, as it is designed to help the book lay flat as you draw.

table of contents

5 foreword

7 introduction

29 drawings

31 head and neck

47 torso

57 upper limb

83 lower limb

96 resources

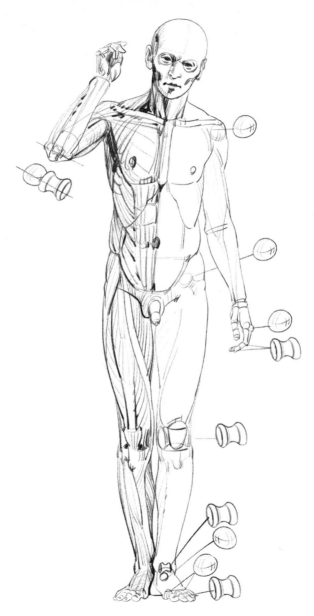

foreword

This book is about the relationship of form and function of the human body. Working similarly to paleontologists, we artists can deduce the functions of the bony structures by observing the sizes of the bones, their joints, and the uneven shapes created on their surfaces by the repeated traction of the muscles that attach to them. The highly developed mechanisms of the human form continue to inspire each new generation of engineers and artists. In biomechanics and biomimicry, we continue to get closer to these natural shapes; and knowing what marvels of adaptation these structures are, we appreciate the aesthetic and poetic potential they represent.

In this book, we are going to work backwards. We will rely on simplified shapes, drawn from a purely mechanical vision, to explain the natural shapes. Beginning with the shapes of the joints and the bones, we will consider them as levers in order to deduce from them the movements that are possible, and will then construct the écorché, working our way closer to the contours of a human silhouette.

Though we find a great variety of complex shapes in nature, shapes that cannot all be reduced to a mechanistic vision, this approach will allow you to imagine new logical proportions, beyond the ones proposed in this book—imaginary, hybrid, or fantastical shapes, but shapes in which you still maintain the relationships of form and function.

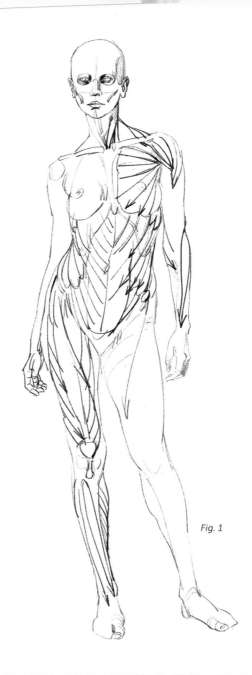

Fig. 1

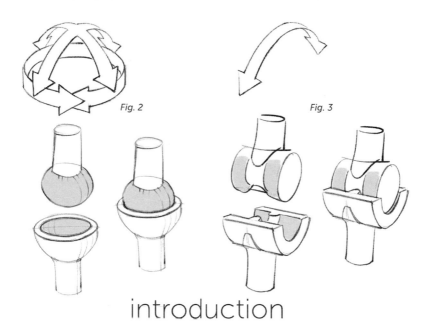

Fig. 2

Fig. 3

introduction

The most important muscles and muscle groups are described in this section, along with their main insertion points and their functions. The goal of this book is to foster your ability to draw from your imagination, supporting it with the study of a mechanical foundation. The study of the entire skeleton was the focus of an earlier volume in this series (*Morpho: Skeleton and Bone Reference Points*); in this book, our focus is on the joint zones and their corresponding musculature. The shape and proportions of the contact surfaces between two bones reflect their possible movements. The joint structures can be seen in a variety of shapes, but for the purposes of our study, we will reduce almost all of them to two major types: the sphere (Fig. 2) and the pulley (Fig. 3).

A sphere allows movement in every direction, while a pulley restricts movement along one possible axis. Your shoulder joint allows your arm to move in all directions due to its spherical form. Your knee, meanwhile, is of the pulley type and movement is limited to a single direction. In the first case (the sphere), we find at least two pairs of opposing muscles positioned along the two principal axes. In the second case (the pulley), there is only one pair of muscles along the single axis.

To counterbalance this mechanical approach, we should make sure not to lose sight of the fact that most of the muscles and bones are in the shape of a helix, and that, together, they make up an effective weave of elements that take turns shaping the human silhouette (Fig. 1).

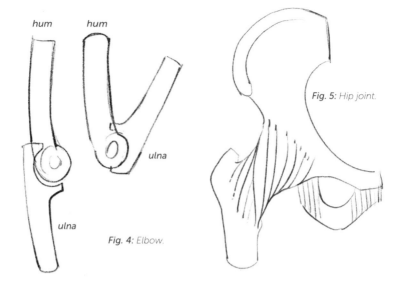

hum hum

ulna

ulna

Fig. 4: Elbow.

Fig. 5: Hip joint.

This helical orientation of the muscle and bone fibers reflects complex movements that go well beyond the four axes—front, back, right, and left—that we have chosen to look at here. This simplification, however, will allow you to familiarize yourself with these morphological notions. You will then be in a position, if need be, to more easily perfect your skills and add nuances to what is presented here.

The joints allow, guide, and limit movements. With the elbow, for instance, the ulna is reduced to movements along a single axis, and presses up against the humerus (hum) during movements of flexion and extension (Fig. 4). However, the bone shapes do not, by themselves, explain the limits of the movements. The bones are held together by a system of links (the ligament) that participate in the formation of joint capsules—fibrous sleeves that envelop the joints and provide a lubricant called synovial fluid, which is secreted by the cartilages (Fig. 5).

The differences in flexibility and range of motion between individuals can have several causes. With babies, for example, their bones are not yet completely calcified and the high proportion of cartilage softens their structure and allows for great flexibility. In adults, the bones can

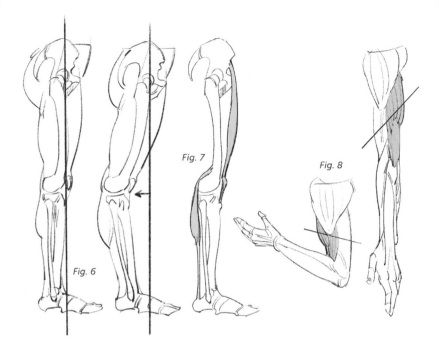

Fig. 7

Fig. 8

Fig. 6

vary in their proportions, length, and sturdiness, and the joints can be more or less enveloping.

The system of ligaments described above can be more or less restrictive. When there is excessive flexibility we speak of joint hyper mobility (Fig. 6, right). And finally, the muscles that operate these bone levers can act only upon these joints (Fig. 7). It is these muscles, which may be more or less elastic, that you first enlist when you stretch after a sustained effort.

The muscles activate the skeleton by attaching to the bones through the medium of their ten-

dons. Tendons and ligaments are often hard to distinguish from each other, because their fibers are intertwined with each other at the joints. Ligaments connect the bones to each other and are part of the skeleton, whereas tendons connect the muscles to the bones and are part of the muscular system. The tendons are not elastic. It is only the fleshy muscular fibers that have this property: Most of all, they are able to contract, with the result that they bring together the bone levers to which they are attached (Fig. 8; note the inverted axes of the contours of the arm).

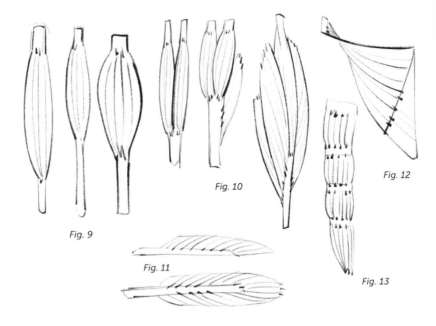

Fig. 9

Fig. 10

Fig. 11

Fig. 12

Fig. 13

The proportion of tendon fibers and muscle fibers can vary from one muscle to another, and, for the same muscle, from one person to another. A short muscle with a long tendon will be able to contract more quickly, but a long muscle will have more flexibility and greater range. Thus, playing with this parameter alone, you can make a person's silhouette look more tense or more flexible (see the two drawings on the left in Fig. 9 and the drawings on the page opposite).

It is the thickness of the muscle that makes one more powerful than another, as well as the increased number of fibers for a given insertion (right-hand drawing in Fig. 9, and on the page opposite).

These muscular fibers are connected in bundles. Several bundles clustered around a single tendon form a biceps (two bundles), a triceps (three bundles), or a quadriceps (four bundles), which gives all the more force to the group as a whole (Fig. 10). The tendons can form a sheathe outside a muscle and/or slide inside another muscle. This pinnate structure (in the shape of a feather) will create a powerful muscle with short fibers (Fig. 11). Surface muscles can form flat sheets connected to tendinous plaques (Fig. 12, latissimus dorsi, often called and/or lats). Others are broken up by tendinous intersections, which tend to reduce their elasticity (Fig. 13, rectus abdominis, commonly known as abs).

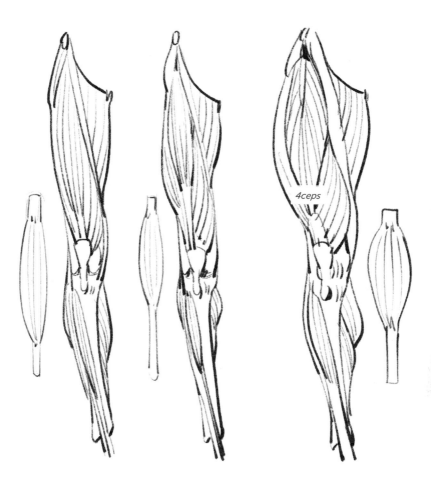

Last but not least, there is the role played by gravity. Our muscular proportions depend on our posture and on the Earth's gravitational pull. For example, the powerful quadriceps, the leg's extensor, allows not only extension (the action of standing up straight), but also controlled flexion (sitting down).

In the following pages, you will find a short review of the bone structures, juxtaposed with their patterns of mobility. These patterns are revisited in the illustrated plates and are shown through a series of écorché drawings throughout the book.

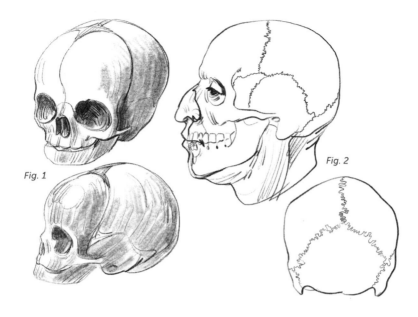

Fig. 1

Fig. 2

Head and Neck

The skull is made up of a number of bony plates. The fontanels in an infant (the space between the bones) allow the skull to change its shape during birth so the baby's head can slip through the narrow passage of the mother's pelvis (Fig. 1). The plates grow to be closely joined (Fig. 2) and become welded together with age.

The lower jaw becomes the only mobile bone in the skull. Its articulation allows for the lifting and lowering motions (Fig. 3) that result from the masseter (1) and temporal (2) chewing muscles (Fig. 4).

The zygomatic arch, a flying buttress that defers some of the pressures, makes it possible for two muscular layers to be superimposed, doubling the force of the mouth's bite and responding to the needs of chewing. An X-ray of the skull shows that the openings—the orbital and nasal pits—slide between the face's bone pillars, which encase these pressures (Fig. 5).

There is a bone marker behind the ear that testifies, through its proportions and its orientation, to its connection with the sternocleidomastoid muscle (3). The name of this muscle is made up of its attachments: the sternum, the clavicle, and the mastoid process (Fig. 6).

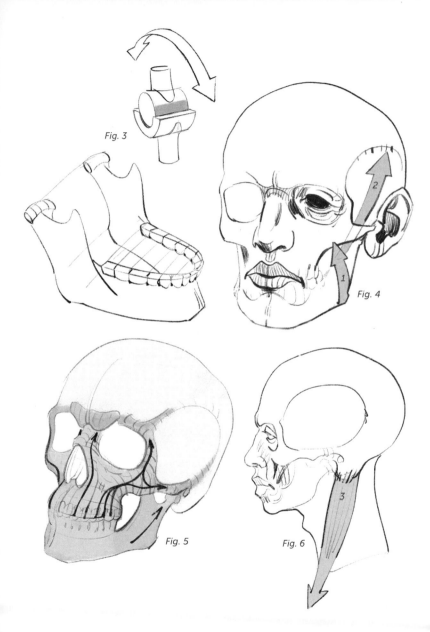

Fig. 3

Fig. 4

Fig. 5

Fig. 6

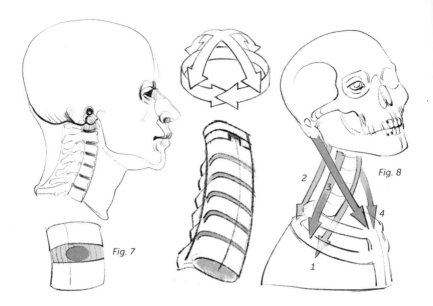

Fig. 8

Fig. 7

The cervical spine is a stack of vertebrae and discs with an elastic core, in which the large number of cervical vertebrae (seven) allows for great flexibility of the neck. Articulated surfaces guide the limited sliding movements of one vertebra against another. It is the intervertebral discs, with their gelatinous cores—veritable elastic mattresses—that distribute pressures and expansions (Fig. 7). Only the bottom two vertebrae of this group—and, most strongly, the seventh, which is the reason it is called the vertebra prominens—can be seen beneath the skin, at the summit of the spine. This marker coincides with the beginning of the first rib; therefore, we can begin drawing the volume of the rib cage at this point. Above these bony prominences, the cervical spine is masked by the fleshy mass of the back of the neck. The cervical spine is articulated below the skull at the level of the jaw joint, in a profile view, where it finds a favorable balance point for our bipedal posture (Fig. 9).

Movements along the four axes (Fig. 8) are connected to the long muscles of the head and the neck (1), of the splenius cervicis (2), and of the cervical scalenes (3). The sternocleidomastoids (4) are responsible for rotation.

Some of these muscles run along the spinal column (1) or reach it with one of their extremities (2). These are deep muscles and are of no use for the understanding of external shapes. In what follows, I will try to illustrate my points with only the muscles that are useful for drawing.

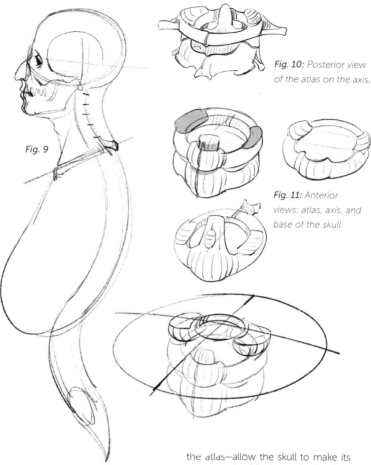

Fig. 10: *Posterior view of the atlas on the axis.*

Fig. 11: *Anterior views: atlas, axis, and base of the skull.*

Fig. 9

I will allow myself a parenthetical remark here, about something that has no influence at all on the external shapes. The two first vertebrae deserve this attention because they constitute a remarkable mechanical relay system between the skull and the other vertebrae. The articular surfaces of the first vertebra—called the atlas—allow the skull to make its movements of flexion and extension.

The Axis is delegated to rotational movement. The atlas, therefore, creates a block with the skull, and they pivot together. You nod your head "yes" by allowing the head to slide along the atlas, and you shake your head "no" by turning the skull and the atlas together on the axis (Figs. 10 and 11).

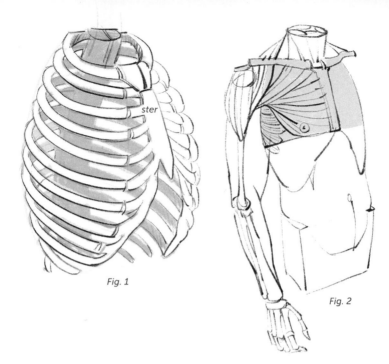

Fig. 1

Fig. 2

Torso

The rib cage is made up of twelve pairs of ribs. The first ten connect in the front with a bony "necktie" called the sternum (ster); the bottom two each have one free extremity and are called floating ribs (Fig. 1). The flexibility of the cartilages that connect the ribs to the sternum give more or less mobility to the whole, and that mobility increases as you move down from top to bottom. Based on this, we can conceive of several functions for this ovoid structure.

The rib cage protects the vital organs, which are the lungs and the heart, but it also allows for the implantation of the muscles that move the shoulders and arms, as well as the muscles that keep the scapula,

in the back, and the pectoral, in the front, in place. The upper part of the rib cage, which is kept rigid by the reduced size of the costal cartilages and the presence at that level of the sternum and of the shoulder girdle (shoulder blades and clavicles), fulfills this function well (Fig. 2). And finally, the rib cage optimizes the lungs' changes in volume during breathing, playing the role of a vacuum chamber. It also supports the diaphragm muscle, which forms a dome from below that moves downward when breathing in. By resisting the contraction, the rib cage allows the lungs to fill with air. The diaphragm plays the role of a piston in a syringe, while the rib cage is the rigid tube (see next page).

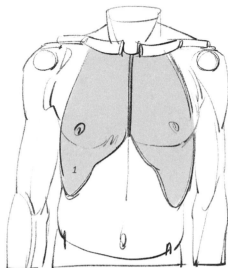

1. Exhaling.

2. Inhaling.

3. Action of the diaphragm muscle.

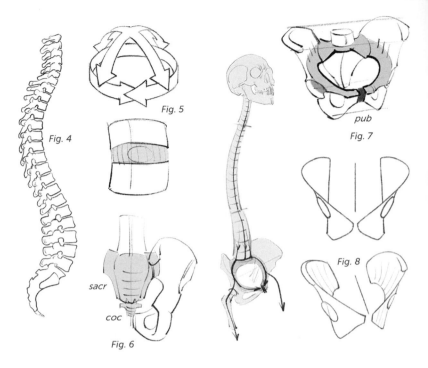

Fig. 5

Fig. 4

Fig. 7

pub

sacr

coc

Fig. 6

Fig. 8

At the back of the rib cage, just below the cervical vertebrae, the twelve dorsal vertebrae have long, tilted spines. Their interdependence with the ribs and the sternum helps to ensure the rigidity of the whole. Moving down, the next group consists of the five lumbar vertebrae, which have a more dynamic character, with spines that are notably more spaced out (Fig. 4). The stacked lumbar vertebrae support the weight of the upper body and, often, additional burdens as well. For this reason, they tend to become larger and more resistant as they move downward. The same is true for the intervertebral discs (Fig. 5).

The sacrum (sacr) is made up of five welded vertebrae (Fig. 6), and the

coccyx (coc) is made up of four caudal vertebrae. The sacrum creates a corner between the two iliac wings and makes up part of the pelvic ring (Fig. 7), which distributes weight to the femurs. The cartilage of the pubis (or pubic symphysis, pub) plays the role of a shock absorber.

If we were simply marionettes hanging from wires, we wouldn't need anything else to connect our trunk to our thighs. However, in order to move the trunk above this ring, and the thighs below it, more space is required. In fact, there are wide plates that complete this system and offer the necessary surfaces for muscular insertions.

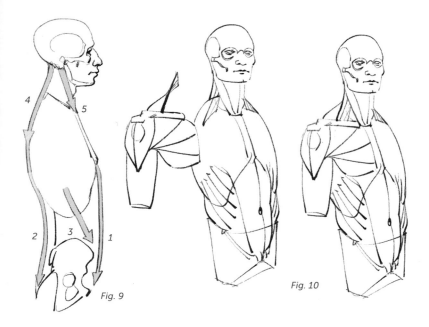

Fig. 9

Fig. 10

These plates are positioned on either side of the hip joints. Above, they connect with the sacrum at the back, below the pubis. The pelvis therefore looks like two connected helixes whose axes correspond to the hip joints (Fig. 8).

The musculature of the torso becomes smaller at the abdominal belt: the rectus abdominis (abs) in front (1), spinal muscles (2) at the rear, and the large oblique muscles on either side (3). These, combined, move the rib cage, above the pelvis, in the four directions. The tilt of the lateral bundles (3) means that rotation is also possible (Fig. 9).

These muscles are part of a relay system with the neck muscles, which I mentioned earlier: the splenius cervicis (4) and the sternocleidomastoid (5).

In terms of mechanics, all of the muscles and bones (including the scapular belt) that sit atop the apparatus described here belong to the arm. Their purpose is to operate the arm, and for this reason I include then in the section on the upper limb (Fig. 10).

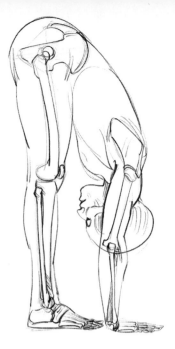
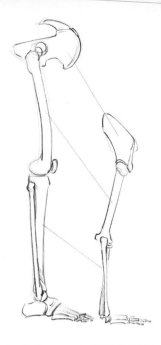

The Limbs

If we compare the upper and lower limbs, starting at the scapular belt (the shoulder blades and clavicles) and the pelvic belt (the pelvis), we can see there is possibly a shared organizing system, which allows us to notice the adaptive differences (a comparison with other mammals also carries important lessons, but that is outside the scope of this work). Thus, the shoulder blade corresponds to the iliac wing, the humerus corresponds to the femur, and the radius and ulna correspond to the tibia and fibula. So there is one single bone in the first segment (upper arm and thigh); there are two in the second segment (forearm and lower leg); and there is a series of small bones at the wrist and at the instep. And finally, the hand and the foot each have five digits, each with the same number of bones and the same kinds of joints (with the thumb and the big toe each having one phalange less).

It is interesting to note that the presence of two bones each in the lower leg and forearm means there is a greater amount of surface space available for the muscles that operate the hands and feet, a correlation that is revealed through the fact that whenever the number of digits is reduced to two or only one (as in the split hoof of bovines or the single hoof of horses, for example), one of these two bones is also lost.

Starting with the two bones of the forearm we find a system that combines rotation and flexion, with one of the two bones being able to cross the other (Fig. 1).

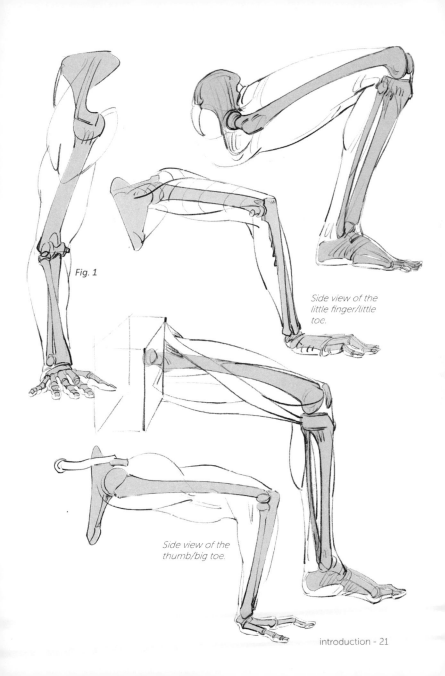

Fig. 1

Side view of the little finger/little toe.

Side view of the thumb/big toe.

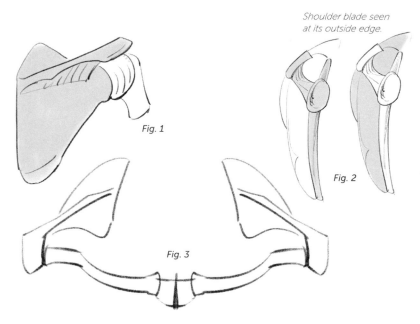

Shoulder blade seen at its outside edge.

Fig. 1

Fig. 2

Fig. 3

Upper Limb

The shoulder blades are platforms that offer a lovely insertion surface for the arm muscles (Fig. 1). You shall see that, in connection with the clavicles, the shoulder blades allow for the limb to be completely raised.

The shoulder blade has a bony blade called a spine that is connected to the clavicle. This shape increases the insertion surface, allowing the muscular fibers of the shoulder to overlap and thus providing an increase in power (Fig. 2, correspondence between the bony and muscular shapes). The connection between the two clavicles and the two shoulder blades on the sternum forms the scapular belt (Fig. 3).

The shoulder joint is the meeting of a spherical humerus head with a surface on the shoulder blade that is not very enveloping, which gives it great mobility in every direction (Figs. 4 and 5).

The four axes are mostly made up by the relay system of the deltoid and trapezius muscles (1) for elevation; the relay system between the teres major and the latissimus dorsi (2) in the back and the pectoral (2) for lowering; and the pectoral again (3) and the infraspinatus (4) for lateral movements. Indeed, a number of muscles, like the pectoral, are made up of fan-shaped bundles that allow for the muscle to participate in a variety of functions. Here, I have isolated two of the four bundles that this muscle includes. In the plates that follow you will find a more detailed analysis.

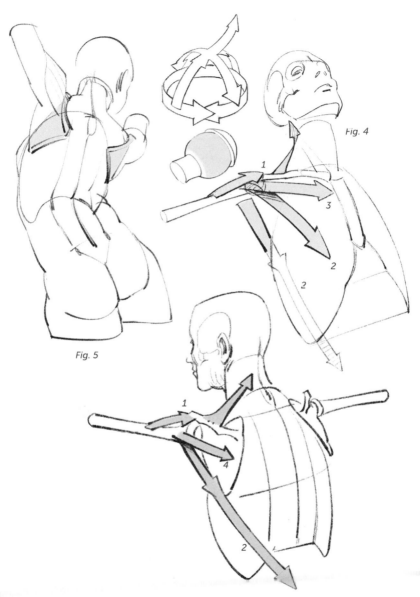

Fig. 4

Fig. 5

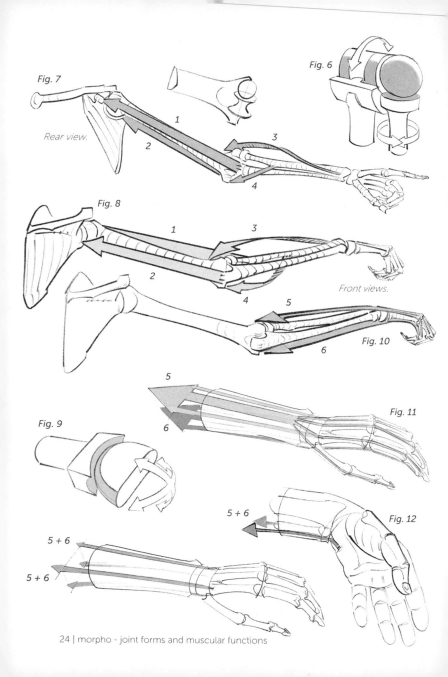

Fig. 7

Rear view.

1

2

3

4

Fig. 6

Fig. 8

1

3

2

4

Front views.

5

6

Fig. 10

5

6

Fig. 11

Fig. 9

5 + 6

Fig. 12

5 + 6

5 + 6

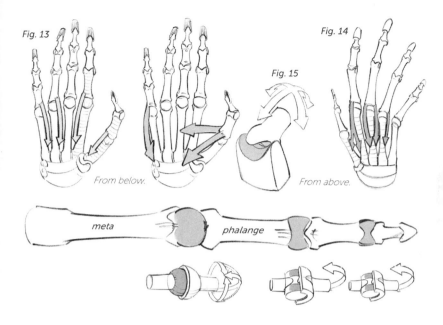

Fig. 13

From below.

Fig. 14

Fig. 15

From above.

meta

phalange

The skeleton allows the forearm to both bend and rotate. At the elbow, we find two connected joints (Fig. 6): a sphere (for rotation) and a pulley (for flexion and extension). The bending of the arm is possible thanks to the opposing functions of the brachial and biceps muscles (1), on one side, and the triceps (2) on the other. Rotation depends on the brachioradial muscles (3) and the pronator teres (4) (Figs. 7 and 8). I will qualify these points and refine these drawings in some of the later plates.

When it crosses the ulna, the radius pulls the hand along with it. The wrist bones form a rounded shape (Fig. 9). Two symmetrical and antagonistic systems face off in the extensors (5) and flexors (6) (Figs. 10 and 11), while the lateral bundles of these two groups pull the hand along the sides (Fig. 12).

The fingers bend on the heads of the metacarpals (meta) thanks to the extensors, the flexors (Fig. 11, 5 and 6), and the interosseous muscles (Figs. 13 and 14); while the joints between the phalanges allow movements of only flexion and extension (Fig. 11, extensors [5] and flexors [6]).

The thumb deserves particular attention. It has a "saddle" joint and is operated by an independent muscular system (Fig. 15).

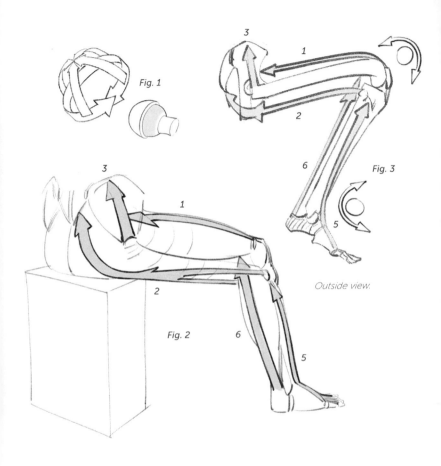

Fig. 1

Fig. 2

Fig. 3

Outside view.

Lower Limb

At the hip, we find a spherical joint similar to the shoulder, but in a more enveloping and constraining version (Fig. 1): This joint has to bear the weight of the body and is constantly working during walking or running. Movements in most directions are possible, although the region's strong ligaments quickly lock down backward movement. For complete movement, we need the quadriceps (1), the relay system of the hamstrings and the gluteus maximus (2), the gluteus medius (3), and the adductors (4) (Figs. 2, 3, and 4). I will refine this system further below.

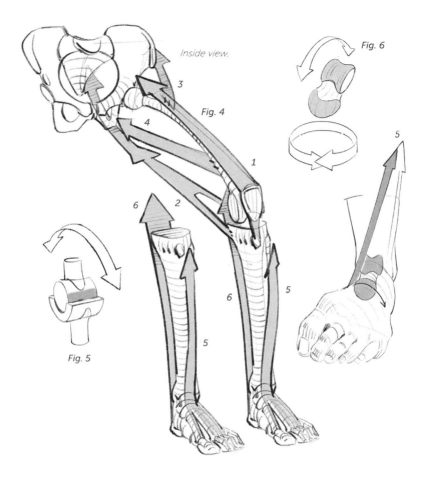

Inside view.

Fig. 6

Fig. 4

Fig. 5

The knee, reduced to a pulley (Fig. 5), leads to the presence of extensors and flexors. Here we find the quadriceps (1) and the hamstrings (2), with these two systems intersecting with two joints: the hip and the knee.

The ankle is also reduced to a pulley-type shape, with the exten-sors (5) and the triceps surae flexor (6) on either side. Twisting move-ments are deferred to the instep. This mechanical solution is based on the astragalus bone, or talus (Fig. 6). Lateral twisting movements are due to the action of leg muscles that echo the disposition you saw on the forearm.

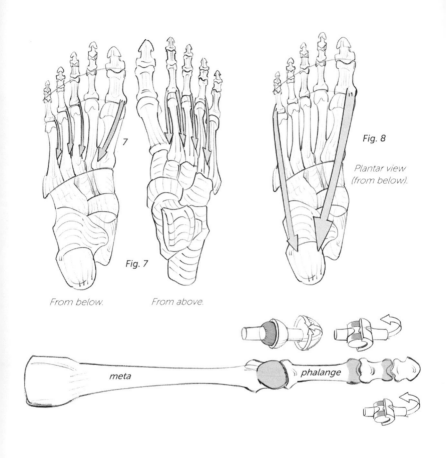

7

Fig. 8

*Plantar view
(from below).*

Fig. 7

From below. *From above.*

meta phalange

The ends of the toes echo the layout of the hand, simplified by the fact that the big toe is not opposable. The extensors (5) and flexors (6) associated with the muscles of the toes (the interosseous mus-cles, 7) allow the same movements (Fig. 7). The foot has to support the weight of the body—you will see the significance of a musculature that is able to maintain the shape of the plantar arch (Fig. 8).

drawings

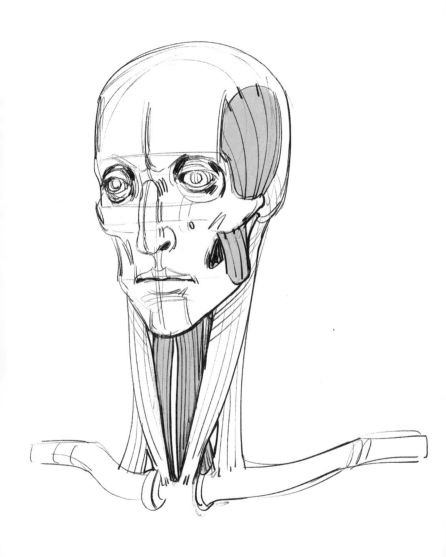

head and neck

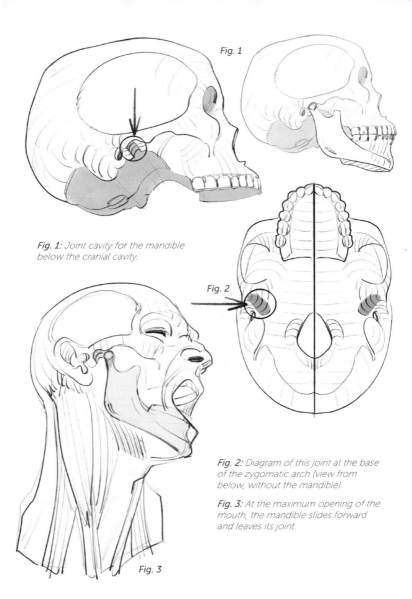

Fig. 1

Fig. 1: *Joint cavity for the mandible below the cranial cavity.*

Fig. 2

Fig. 2: *Diagram of this joint at the base of the zygomatic arch (view from below, without the mandible).*

Fig. 3: *At the maximum opening of the mouth, the mandible slides forward and leaves its joint.*

Fig. 3

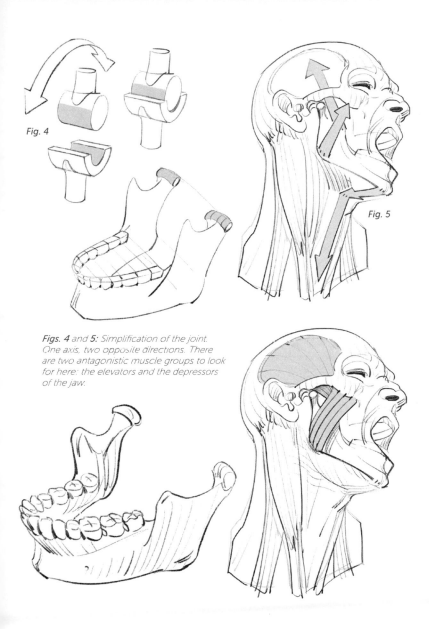

Figs. 4 and *5:* Simplification of the joint. One axis, two opposite directions. There are two antagonistic muscle groups to look for here: the elevators and the depressors of the jaw.

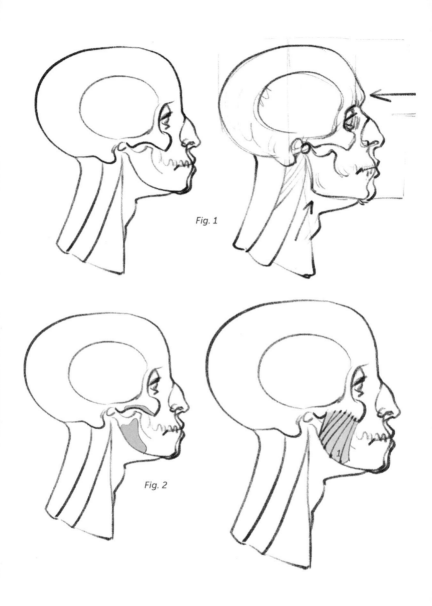

Fig. 1

Fig. 2

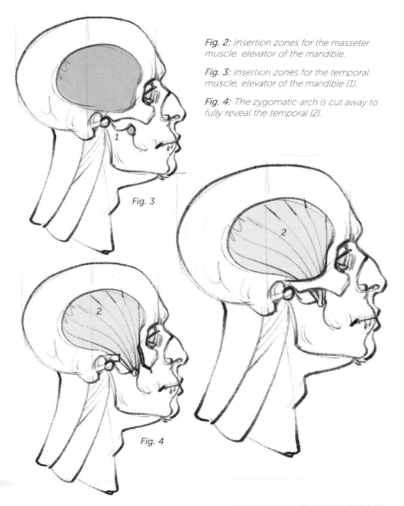

Fig. 1: Feminine skull on the left; masculine skull on the right. The strength of the jaw muscles leads to greater or lesser bone structures. The lower arrow points to the angle of the mandible (for the insertion of the masseter). The upper arrow points to the frontal hump (the bone brake for pressure). The consequences of this humped shape are the masculine characteristics of a depression at the bridge of the nose and a receding forehead. A nose that is within the extension of a more vertical and curved forehead is a feminine characteristic.

Fig. 2: insertion zones for the masseter muscle, elevator of the mandible.

Fig. 3: insertion zones for the temporal muscle, elevator of the mandible (1).

Fig. 4: The zygomatic arch is cut away to fully reveal the temporal (2).

Fig. 3

Fig. 4

Fig. 1

Figs. 1 and 2: The masseter (1) and temporal (2) muscles are two elevator muscles for the mandible (1 and 2).

Fig. 3: The zygomatic arch is cut away to reveal the temporal (2).

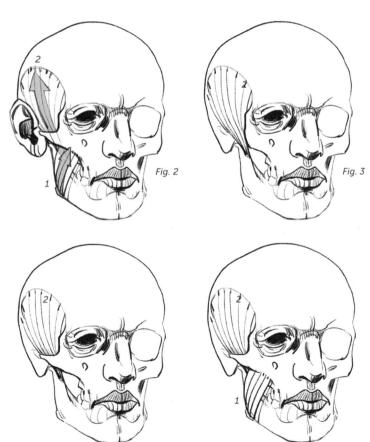

Fig. 2

Fig. 3

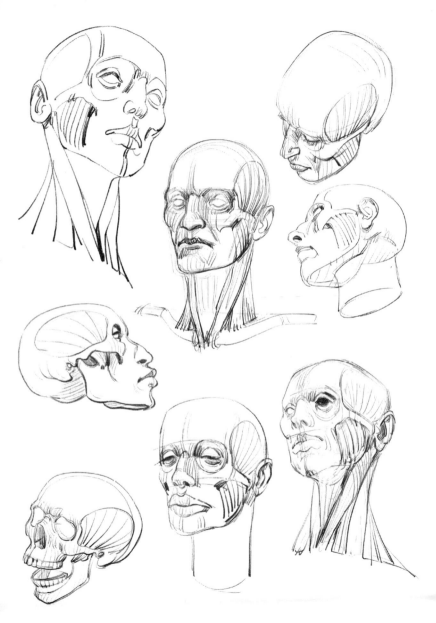

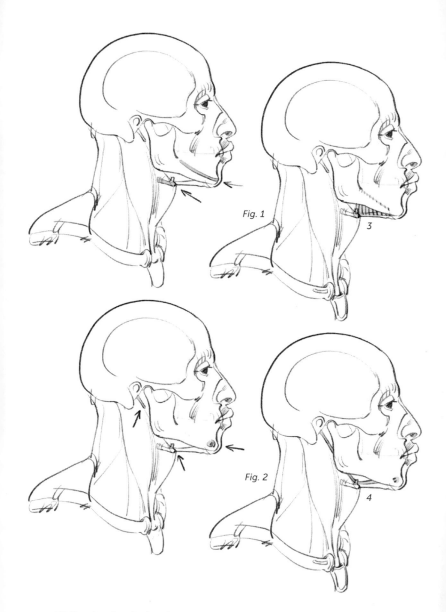

Fig. 1

3

Fig. 2

4

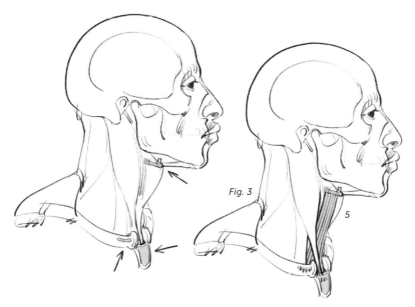

There are several muscles involved in the movements of the lower jaw. The masseter and temporal elevators are powerful chewing muscles and are significant for the study of shapes. The same is not true for the depressors, which cover, but do not hide, the larynx and the trachea. I will mention just three of them here:

Fig. 1: Insertions of the mylohyoid muscle.

Fig. 2: Insertions of the digastric muscle.

Fig. 3: Insertions of the sternocleidomastoid muscle.

Fig. 4: The hyoid bone (hy) is a small horseshoe-shaped bone, shown here in profile. It is located at the junction of the neck and the bottom of the chin. It serves as a relay point for the depressor muscles shown on this spread. These muscles also allow for the suspension of the larynx – represented here by the thyroid cartilage (thy), or Adam's apple—and its movements during swallowing.

The hyoid bone presents a small horn shape for the insertion of the digastric muscle (see following pages).

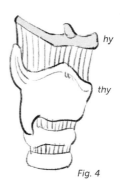

Fig. 4

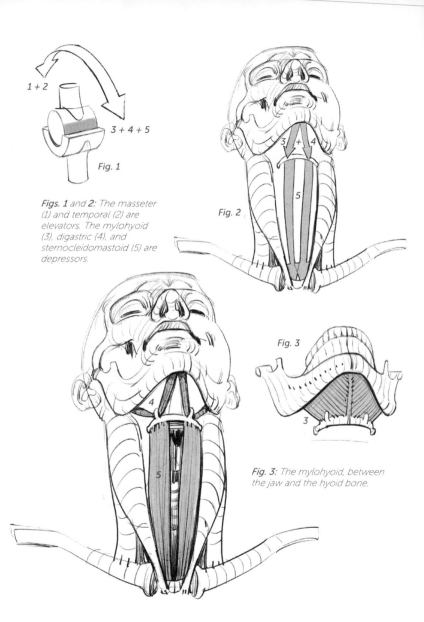

Figs. 1 and **2:** The masseter (1) and temporal (2) are elevators. The mylohyoid (3), digastric (4), and sternocleidomastoid (5) are depressors.

Fig. 3: The mylohyoid, between the jaw and the hyoid bone.

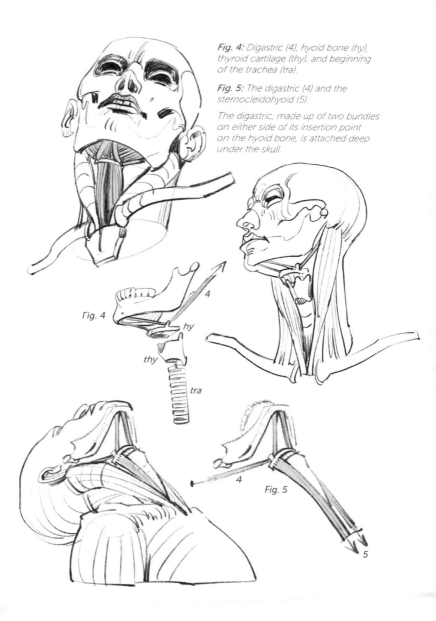

Fig. 4: *Digastric (4), hyoid bone (hy), thyroid cartilage (thy), and beginning of the trachea (tra).*

Fig. 5: *The digastric (4) and the sternocleidohyoid (5).*

The digastric, made up of two bundles on either side of its insertion point on the hyoid bone, is attached deep under the skull.

Гig. 4

4

hy

thy

tra

4

Fig. 5

5

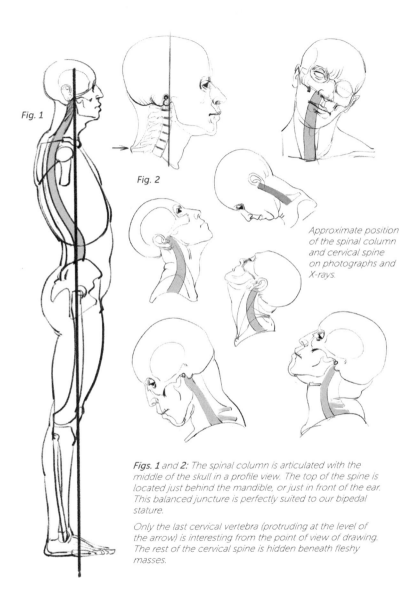

Fig. 1

Fig. 2

Approximate position of the spinal column and cervical spine on photographs and X-rays.

Figs. 1 and *2*: *The spinal column is articulated with the middle of the skull in a profile view. The top of the spine is located just behind the mandible, or just in front of the ear. This balanced juncture is perfectly suited to our bipedal stature.*

Only the last cervical vertebra (protruding at the level of the arrow) is interesting from the point of view of drawing. The rest of the cervical spine is hidden beneath fleshy masses.

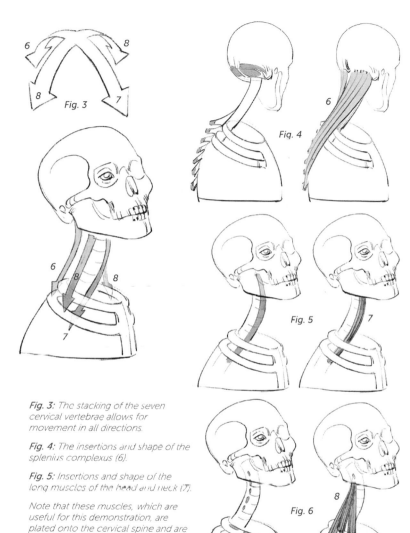

Fig. 3: The stacking of the seven cervical vertebrae allows for movement in all directions.

Fig. 4: The insertions and shape of the splenius complexus (6).

Fig. 5: Insertions and shape of the long muscles of the head and neck (7).

Note that these muscles, which are useful for this demonstration, are plated onto the cervical spine and are therefore invisible.

Fig. 6: Insertions and shape of the scalene muscles (8).

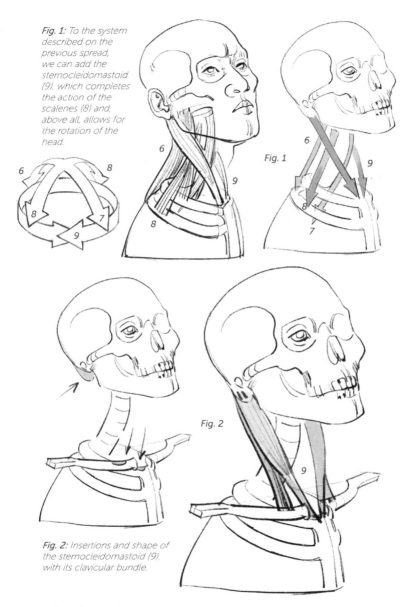

Fig. 1: To the system described on the previous spread, we can add the sternocleidomastoid (9), which completes the action of the scalenes (8) and, above all, allows for the rotation of the head.

Fig. 1

Fig. 2: Insertions and shape of the sternocleidomastoid (9), with its clavicular bundle.

Fig. 2

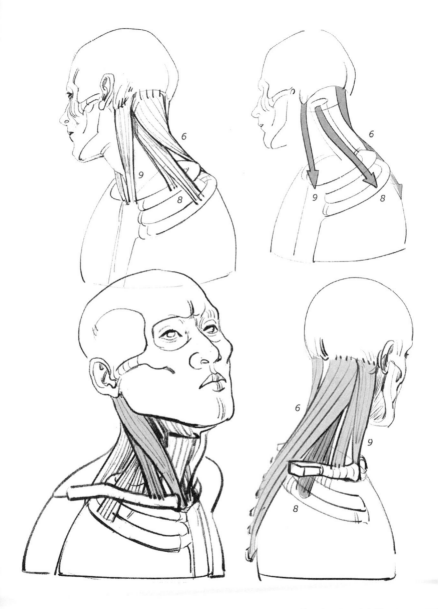

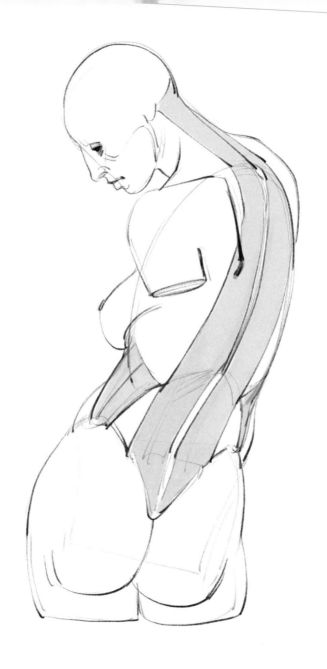

torso

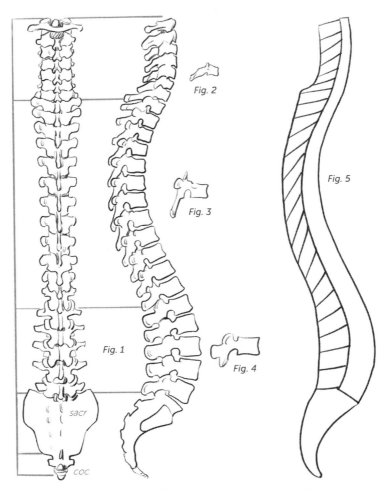

Fig. 1: Dorsal and profile views. The spinal column is composed of 7 cervical, 12 dorsal, and 5 lumbar vertebrae; the sacrum (sacr) is composed of 5 welded verbetrae; and the tailbone, or coccyx (coc), is composed of 4 vertebrae.

Fig. 2: Cervical vertebra (see page 15).

Fig. 3: Dorsal vertebra.

Fig. 4: Lumbar vertebra.

Fig. 5: Rhythm of the dorsal spines.

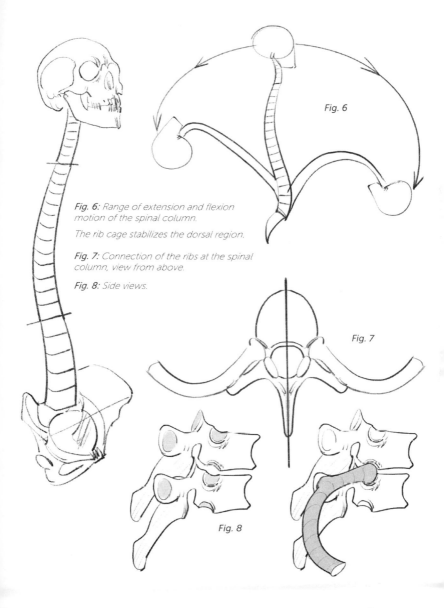

Fig. 6: *Range of extension and flexion motion of the spinal column.*

The rib cage stabilizes the dorsal region.

Fig. 7: *Connection of the ribs at the spinal column, view from above.*

Fig. 8: *Side views.*

Fig. 6

Fig. 7

Fig. 8

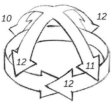

Fig. 1

Fig. 1: *The stacking of the vertebrae allows for movement in all directions.*

The spinals (10) are extensors; the rectus abdominis (abs, 11) are flexors; and the obliques (12), due to their orientation, allow for lateral tilting and rotation.

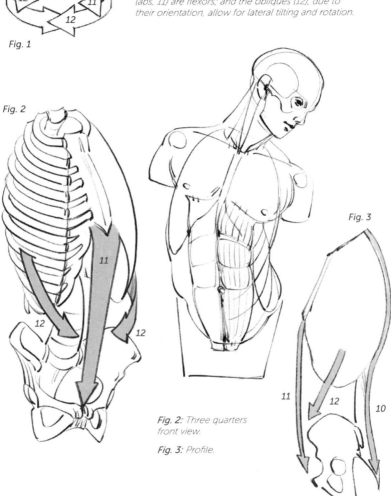

Fig. 2: *Three quarters front view.*

Fig. 3: *Profile.*

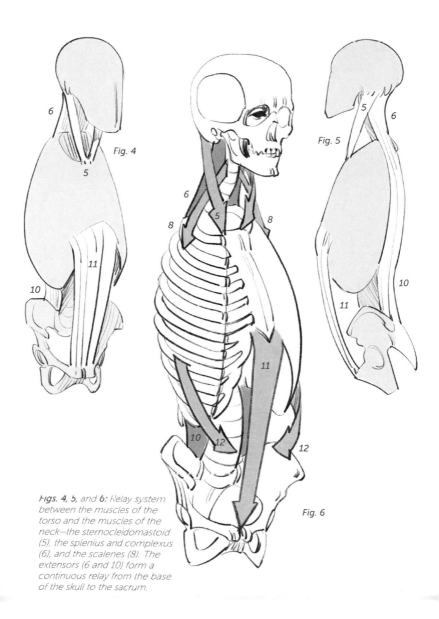

Fig. 4

Fig. 5

Fig. 6

Figs. 4, 5, and 6: Relay system
between the muscles of the
torso and the muscles of the
neck—the sternocleidomastoid
(5), the splenius and complexus
(6), and the scalenes (8). The
extensors (6 and 10) form a
continuous relay from the base
of the skull to the sacrum.

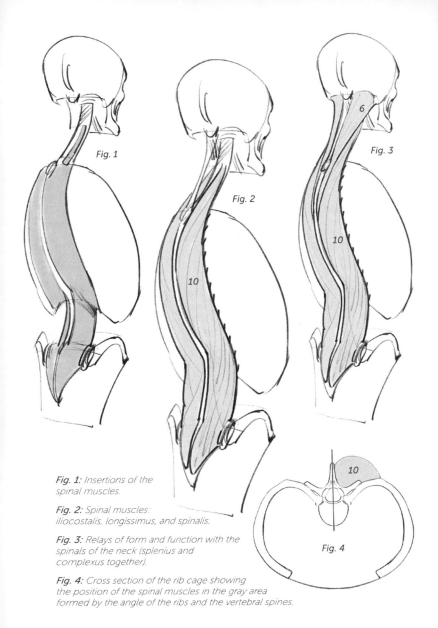

Fig. 1: Insertions of the spinal muscles.

Fig. 2: Spinal muscles: iliocostalis, longissimus, and spinalis.

Fig. 3: Relays of form and function with the spinals of the neck (splenius and complexus together).

Fig. 4: Cross section of the rib cage showing the position of the spinal muscles in the gray area formed by the angle of the ribs and the vertebral spines.

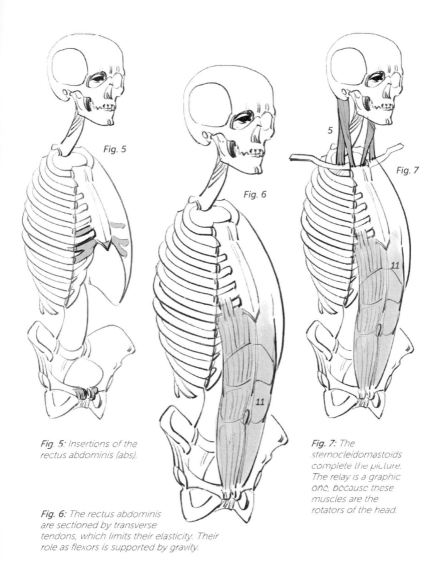

Fig. 5: Insertions of the rectus abdominis (abs).

Fig. 6: The rectus abdominis are sectioned by transverse tendons, which limits their elasticity. Their role as flexors is supported by gravity.

Fig. 7: The sternocleidomastoids complete the picture. The relay is a graphic one, because these muscles are the rotators of the head.

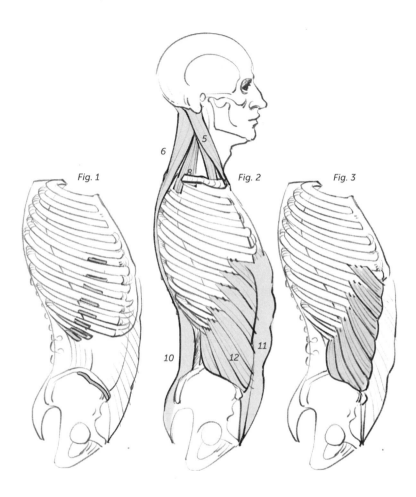

Fig. 1: Insertion points of the obliques.

Fig. 2: Relays with the neck muscles.

Figs. 3 and *4:* On each side, the oblique muscles pass in front of the rectus abdominis and reconnect by crisscrossing their tendinous fibers along the median line (white line), which they thus help to form.

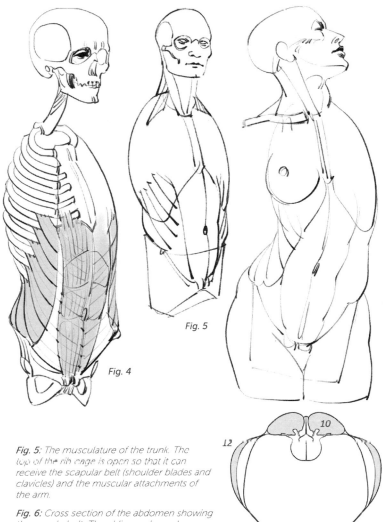

Fig. 5

Fig. 4

Fig. 5: *The musculature of the trunk. The top of the rib cage is open so that it can receive the scapular belt (shoulder blades and clavicles) and the muscular attachments of the arm.*

Fig. 6: *Cross section of the abdomen showing the muscle belt. The obliques shown here occupy only the outermost layer of the lateral muscles.*

Fig. 6

upper limb

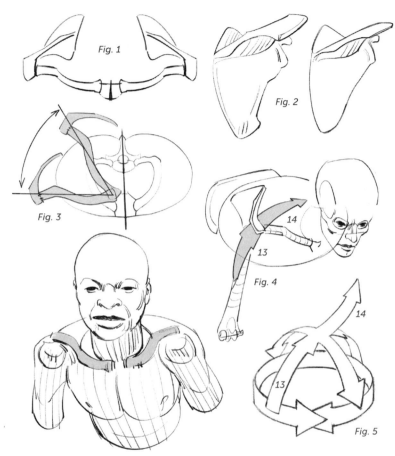

Fig. 1: Scapular belt seen from above. Mechanically speaking, the clavicles and shoulder blades can be considered as the first bones of the upper limb.

Fig. 2: On the left is a more masculine, more robust shoulder blade, adapted to a more powerful musculature; on the right is a more feminine, more delicate shoulder blade.

Fig. 3: Range of motion of the clavicles and shoulder blades seen from above.

Figs. 4 and 5: Synergy between the deltoid (13) and the trapezius (14).

The deltoid and the trapezius muscles alternate with each other on either side of the scapular belt.

Fig. 6: *Insertion points of the deltoid.*

Fig. 7: *Insertion points of the trapezius, which starts from the shoulder blade and clavicle to join the spinal column and the skull.*

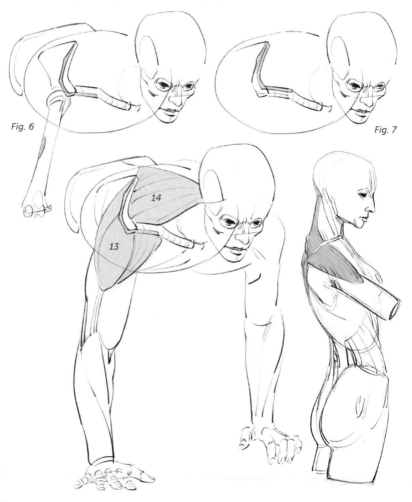

Fig. 6

Fig. 7

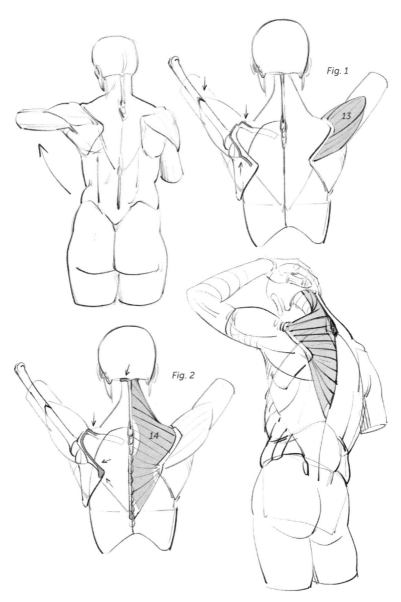

Fig. 1

13

Fig. 2

14

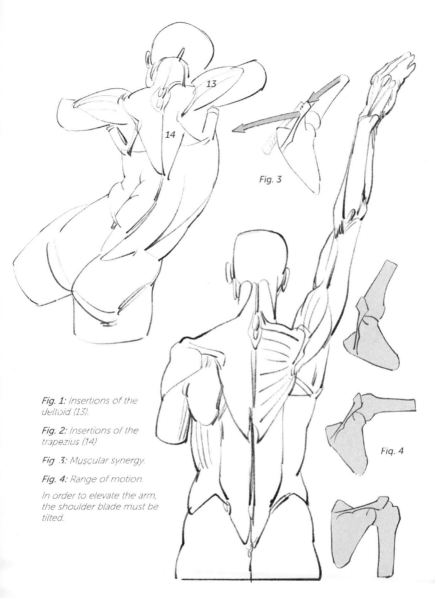

Fig. 1: Insertions of the deltoid (13).

Fig. 2: Insertions of the trapezius (14).

Fig. 3: Muscular synergy.

Fig. 4: Range of motion.

In order to elevate the arm, the shoulder blade must be tilted.

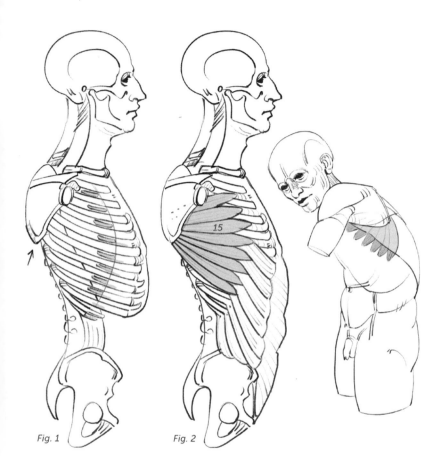

Fig. 1: Insertions of the anterior serratus.

Fig. 2: Serratus anterior muscle (15).

Connections between the serratus anterior and the large oblique (see page 54).

Figs. 3 and *4:* Synergiy between the deltoid (13), the trapezius (14), and the serratus anterior (15). The clavicle, attached to the sternum, forces the shoulder blade to tilt and makes it possible to completely raise the arm.

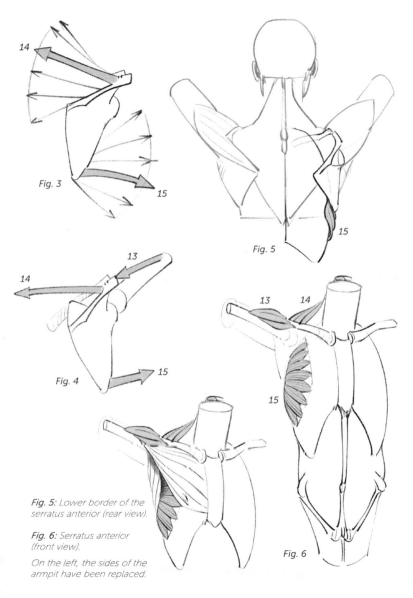

Fig. 5: Lower border of the serratus anterior (rear view).

Fig. 6: Serratus anterior (front view).

On the left, the sides of the armpit have been replaced.

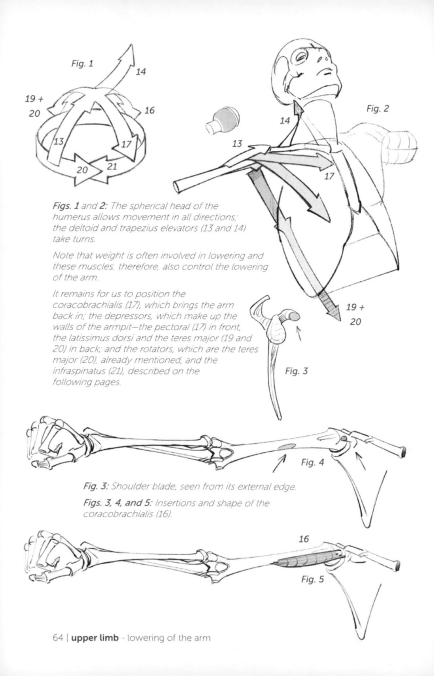

Figs. 1 and 2: *The spherical head of the humerus allows movement in all directions; the deltoid and trapezius elevators (13 and 14) take turns.*

Note that weight is often involved in lowering and these muscles, therefore, also control the lowering of the arm.

It remains for us to position the coracobrachialis (17), which brings the arm back in; the depressors, which make up the walls of the armpit—the pectoral (17) in front, the latissimus dorsi and the teres major (19 and 20) in back; and the rotators, which are the teres major (20), already mentioned, and the infraspinatus (21), described on the following pages.

Fig. 3: *Shoulder blade, seen from its external edge.*

Figs. 3, 4, and 5: *Insertions and shape of the coracobrachialis (16).*

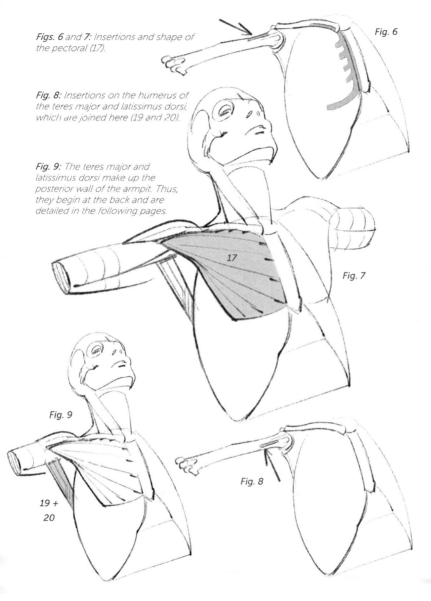

Figs. 6 and *7: Insertions and shape of the pectoral (17).*

Fig. 6

Fig. 8: Insertions on the humerus of the teres major and latissimus dorsi, which are joined here (19 and 20).

Fig. 9: The teres major and latissimus dorsi make up the posterior wall of the armpit. Thus, they begin at the back and are detailed in the following pages.

17

Fig. 7

Fig. 9

19 + 20

Fig. 8

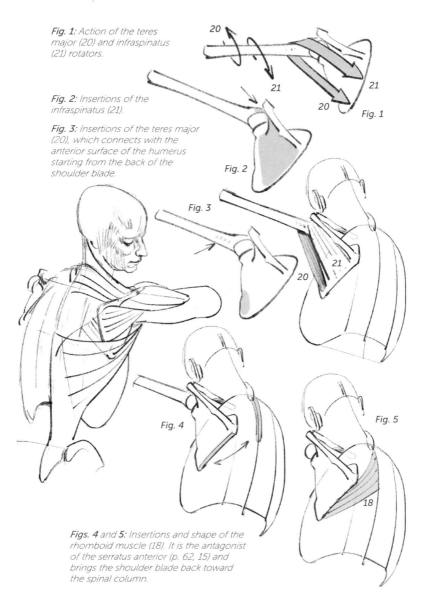

Fig. 1: Action of the teres major (20) and infraspinatus (21) rotators.

Fig. 2: Insertions of the infraspinatus (21).

Fig. 3: Insertions of the teres major (20), which connects with the anterior surface of the humerus starting from the back of the shoulder blade.

Figs. 4 and **5:** Insertions and shape of the rhomboid muscle (18). It is the antagonist of the serratus anterior (p. 62, 15) and brings the shoulder blade back toward the spinal column.

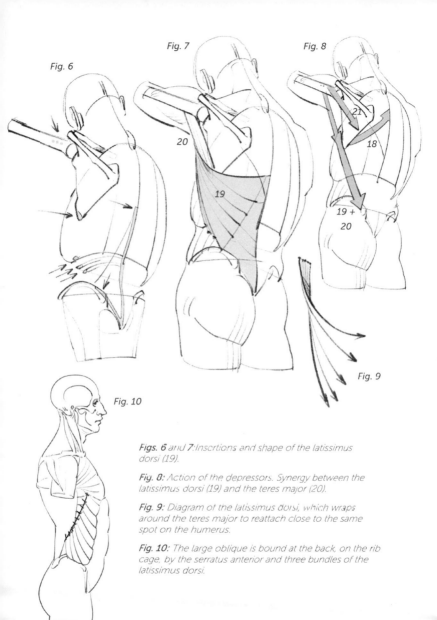

Figs. 6 and **7**: Insertions and shape of the latissimus dorsi (19).

Fig. 8: Action of the depressors. Synergy between the latissimus dorsi (19) and the teres major (20).

Fig. 9: Diagram of the latissimus dorsi, which wraps around the teres major to reattach close to the same spot on the humerus.

Fig. 10: The large oblique is bound at the back, on the rib cage, by the serratus anterior and three bundles of the latissimus dorsi.

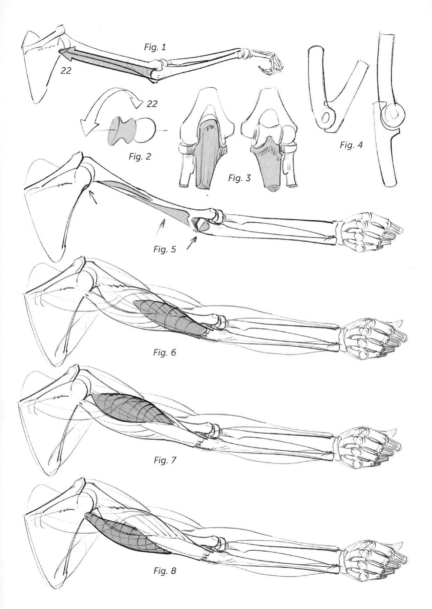

Fig. 1

22

22

Fig. 2

Fig. 3

Fig. 4

Fig. 5

Fig. 6

Fig. 7

Fig. 8

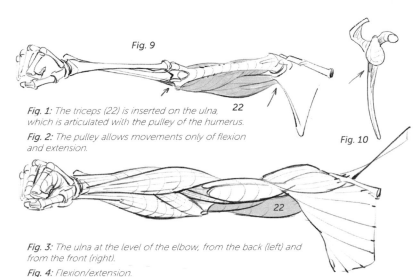

Fig. 9

22

Fig. 1: The triceps (22) is inserted on the ulna, which is articulated with the pulley of the humerus.

Fig. 2: The pulley allows movements only of flexion and extension.

Fig. 10

22

Fig. 3: The ulna at the level of the elbow, from the back (left) and from the front (right).

Fig. 4: Flexion/extension.

Fig. 5: Insertions of the triceps.

Figs. 6, 7, and **8:** The three bundles of the triceps, united by a shared tendon attached to the elbow.

Fig. 9: The triceps (22) seen from the front (with the flexors pulled back, the humerus is visible).

Fig. 10: Shoulder blade visible at its external blade. The insertion of the triceps.

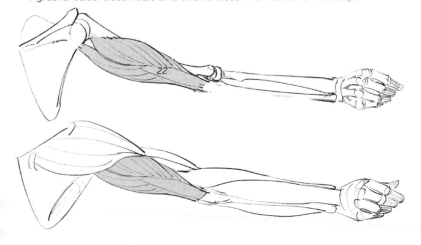

22

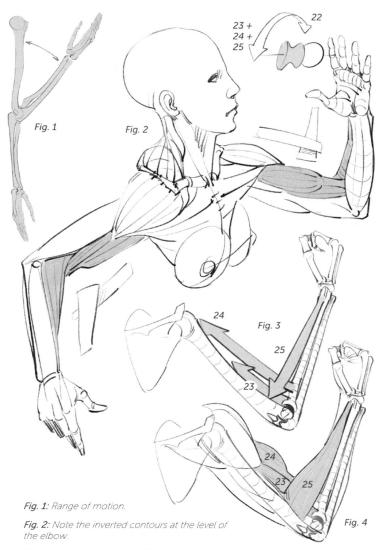

23 +
24 +
25

22

Fig. 1

Fig. 2

24

Fig. 3

25

23

24

23 25

Fig. 4

Fig. 1: Range of motion.

Fig. 2: Note the inverted contours at the level of the elbow.

Figs. 3 and *4:* The brachialis (23), the biceps (24), and the brachioradialis (25) are all flexors.

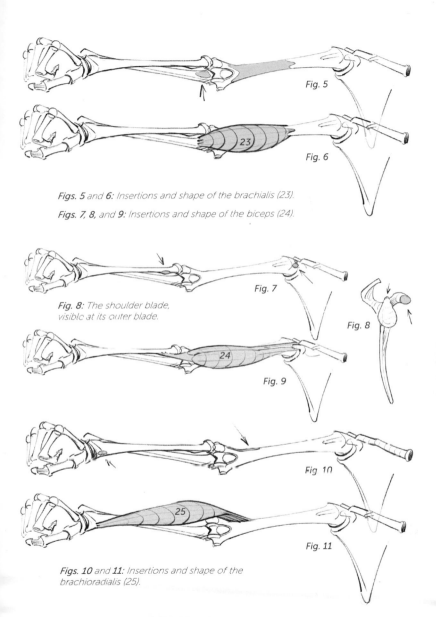

Figs. 5 and *6: Insertions and shape of the brachialis (23).*

Figs. 7, 8, and *9: Insertions and shape of the biceps (24).*

Fig. 8: The shoulder blade, visible at its outer blade.

Figs. 10 and *11: Insertions and shape of the brachioradialis (25).*

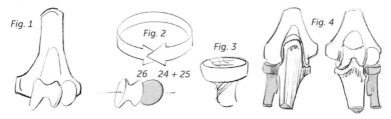

Fig. 1: Extremity of the humerus at the level of the elbow.

Fig. 2: The two joint types (sphere and pulley) are joined together. The movements associated with the two types are therefore associated with the two bones of the forearm: the radius for rotations (sphere) and the ulna for flexions and extensions (pulley).

Fig. 3: The head (cup) of the radius.

Fig. 4: The radius at the elbow, from the back and from the front.

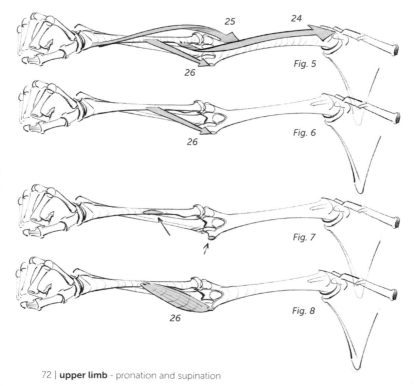

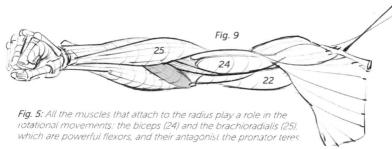

Fig. 5: All the muscles that attach to the radius play a role in the rotational movements: the biceps (24) and the brachioradialis (25), which are powerful flexors, and their antagonist the pronator teres

Fig. 6: Action of the pronator teres.

Figs. 7, 8, and 9: Insertions and shape of the pronator teres (26).

Fig. 10: In pronation (the act of extending), the biceps contracts and its tendon wraps around the radius.

Fig. 11: In supination (the act of supporting), the biceps contract and shorten.

Fig. 12: The amplitude of the rotation is estimated at 120 degrees. With the shoulder taking part in the full movement, the hand can turn 3/4 of a full-circle rotation, the forearm 1/2, and the upper arm 1/4.

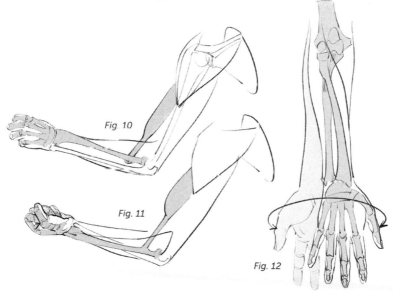

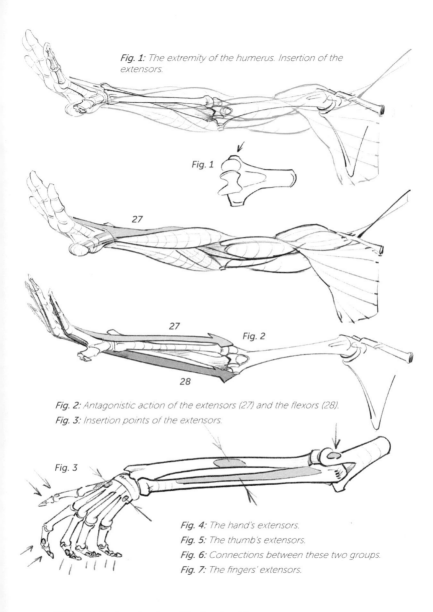

Fig. 1: The extremity of the humerus. Insertion of the extensors.

Fig. 1

27

27 *Fig. 2*

28

Fig. 2: Antagonistic action of the extensors (27) and the flexors (28).
Fig. 3: Insertion points of the extensors.

Fig. 3

Fig. 4: The hand's extensors.
Fig. 5: The thumb's extensors.
Fig. 6: Connections between these two groups.
Fig. 7: The fingers' extensors.

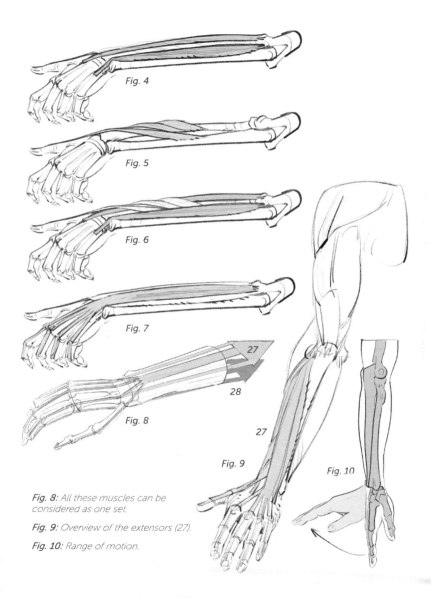

Fig. 4

Fig. 5

Fig. 6

Fig. 7

27

28

Fig. 8

27

Fig. 9

Fig. 10

Fig. 8: All these muscles can be considered as one set.

Fig. 9: Overview of the extensors (27).

Fig. 10: Range of motion.

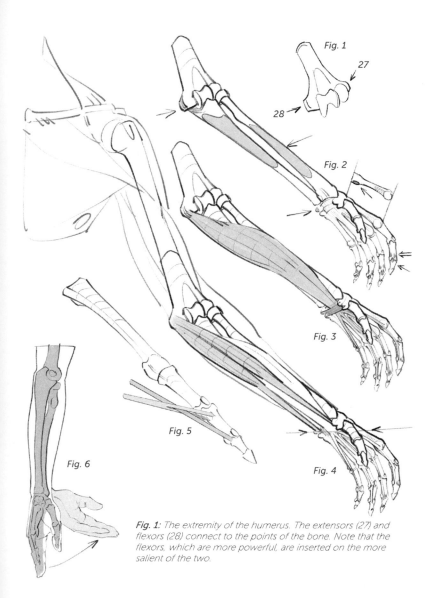

Fig. 1: _The extremity of the humerus. The extensors (27) and flexors (28) connect to the points of the bone. Note that the flexors, which are more powerful, are inserted on the more salient of the two._

Fig. 1

27

28

Fig. 2

Fig. 3

Fig. 5

Fig. 4

Fig. 6

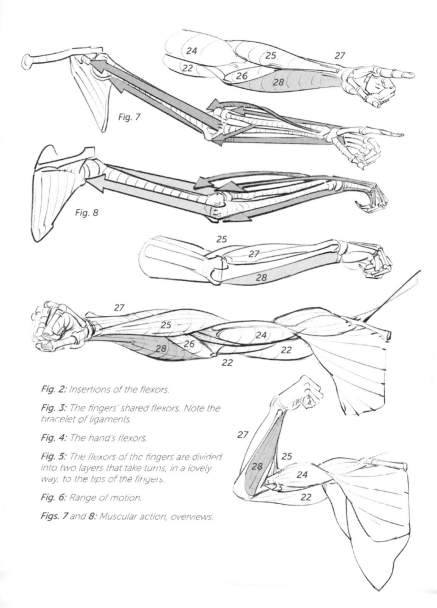

Fig. 2: Insertions of the flexors.

Fig. 3: The fingers' shared flexors. Note the bracelet of ligaments.

Fig. 4: The hand's flexors.

Fig. 5: The flexors of the fingers are divided into two layers that take turns, in a lovely way, to the tips of the fingers.

Fig. 6: Range of motion.

Figs. 7 and *8:* Muscular action, overviews.

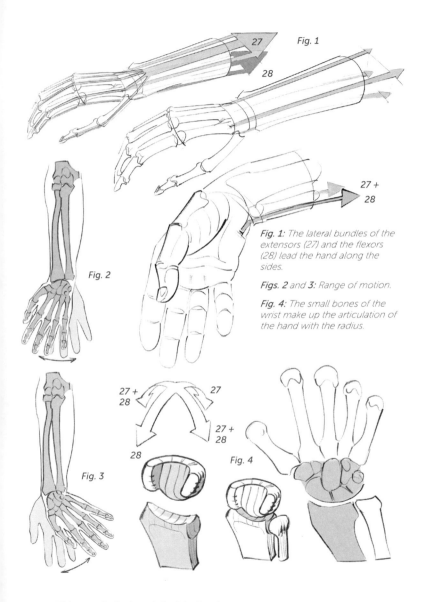

Fig. 1: The lateral bundles of the extensors (27) and the flexors (28) lead the hand along the sides.

Figs. 2 and **3:** Range of motion.

Fig. 4: The small bones of the wrist make up the articulation of the hand with the radius.

27

28

27 + 28

27 + 28

27

27 + 28

28

Fig. 1

Fig. 2

Fig. 3

Fig. 4

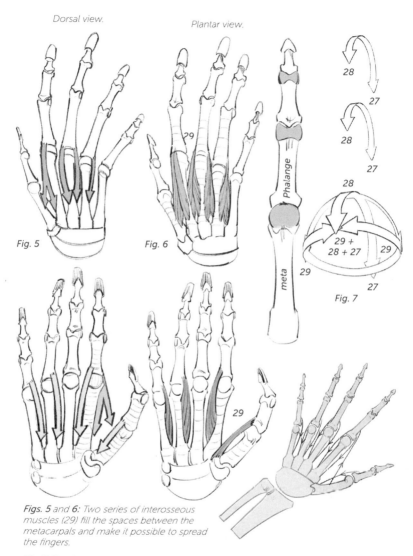

Dorsal view.

Plantar view.

Phalange

meta

28

27

28

27

28

29 +
28 + 27 29

27

Fig. 5

Fig. 6

Fig. 7

Figs. 5 and **6:** *Two series of interosseous muscles (29) fill the spaces between the metacarpals and make it possible to spread the fingers.*

Fig. 7: *The heads of the metacarpals (as seen in a fist) are spherical and thus allow movement in all directions: The extensors and flexors complement and follow their action to the phalanges.*

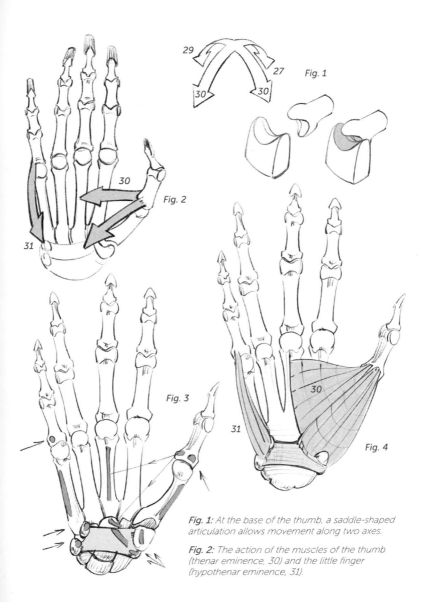

Fig. 1: At the base of the thumb, a saddle-shaped articulation allows movement along two axes.

Fig. 2: The action of the muscles of the thumb (thenar eminence, 30) and the little finger (hypothenar eminence, 31).

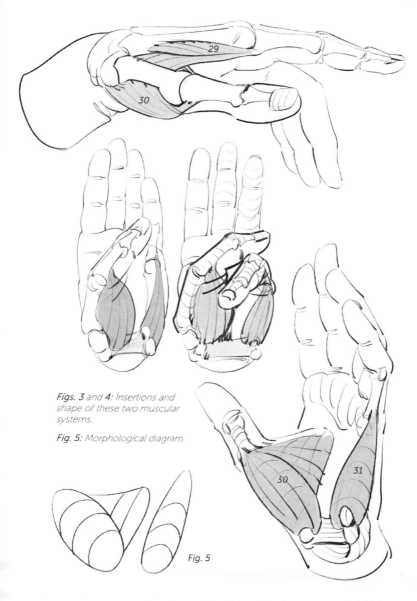

Figs. 3 and *4: Insertions and shape of these two muscular systems.*

Fig. 5: Morphological diagram.

Fig. 5

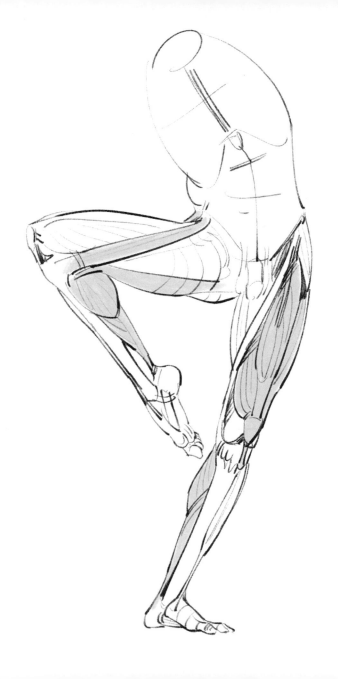

lower limb

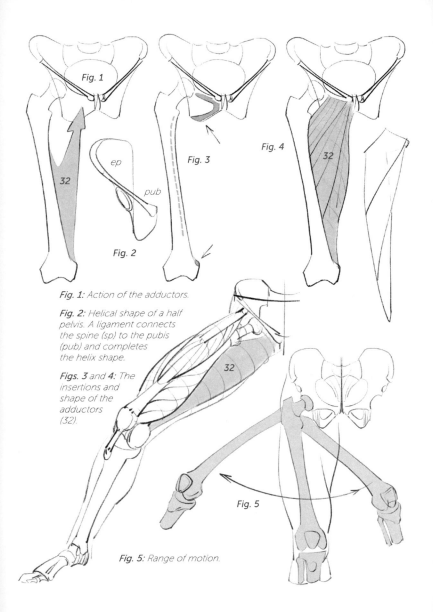

Fig. 1: Action of the adductors.

Fig. 2: Helical shape of a half pelvis. A ligament connects the spine (sp) to the pubis (pub) and completes the helix shape.

Figs. 3 and 4: The insertions and shape of the adductors (32).

Fig. 5: Range of motion.

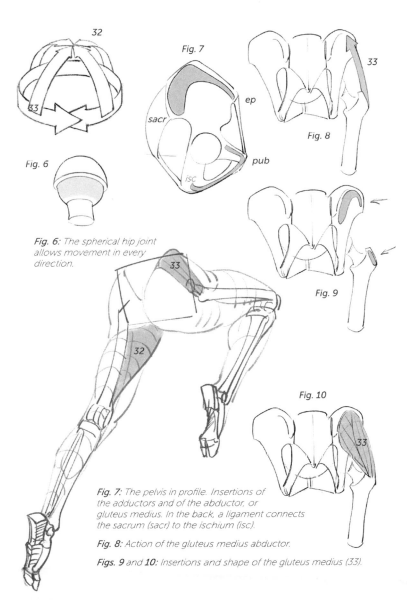

Fig. 6: The spherical hip joint allows movement in every direction.

Fig. 7: The pelvis in profile. Insertions of the adductors and of the abductor, or gluteus medius. In the back, a ligament connects the sacrum (sacr) to the ischium (isc).

Fig. 8: Action of the gluteus medius abductor.

Figs. 9 and **10:** Insertions and shape of the gluteus medius (33).

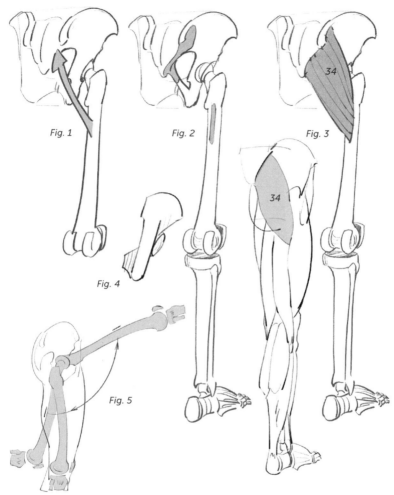

Fig. 1: Action of the gluteus maximus.

Fig. 2: Insertions of the gluteus maximus.

Fig. 3: Shape of the gluteus maximus (34). Note that its lower boundary does not merge with the buttock, which owes its shape to fat.

Fig. 4: From the back, you can again see the helix shape of the pelvis.

Fig. 5: Range of motion.

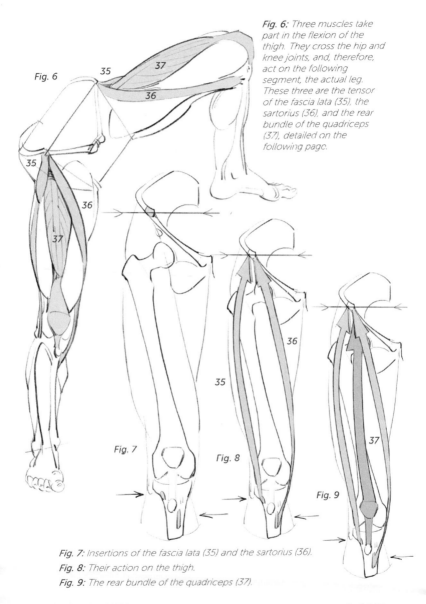

Fig. 6: Three muscles take part in the flexion of the thigh. They cross the hip and knee joints, and, therefore, act on the following segment, the actual leg. These three are the tensor of the fascia lata (35), the sartorius (36), and the rear bundle of the quadriceps (37), detailed on the following page.

Fig. 7: Insertions of the fascia lata (35) and the sartorius (36).

Fig. 8: Their action on the thigh.

Fig. 9: The rear bundle of the quadriceps (37).

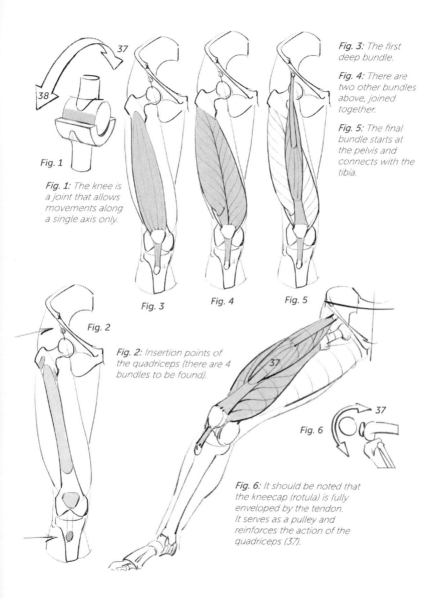

Fig. 3: The first deep bundle.

Fig. 4: There are two other bundles above, joined together.

Fig. 5: The final bundle starts at the pelvis and connects with the tibia.

Fig. 1: The knee is a joint that allows movements along a single axis only.

Fig. 3

Fig. 4

Fig. 5

Fig. 2

Fig. 2: Insertion points of the quadriceps (there are 4 bundles to be found).

Fig. 6

Fig. 6: It should be noted that the kneecap (rotula) is fully enveloped by the tendon. It serves as a pulley and reinforces the action of the quadriceps (37).

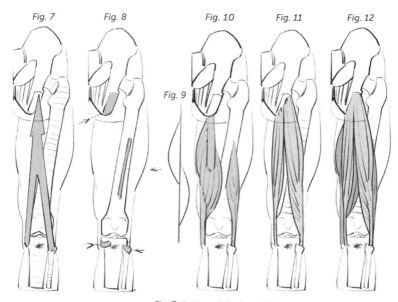

Fig. 7: Action of the hamstrings.

Fig. 8: Their insertions.

Fig. 9: Diagram of the inner bundle, at depth.

Fig. 10: Deep bundles.

Fig. 11: Surface bundles.

Fig. 12: The two layers joined together.

Fig. 13: Here the hamstring (38) is working in tandem with the gluteus maximus (34).

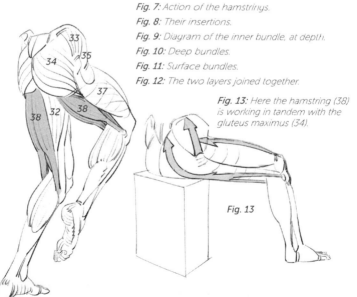

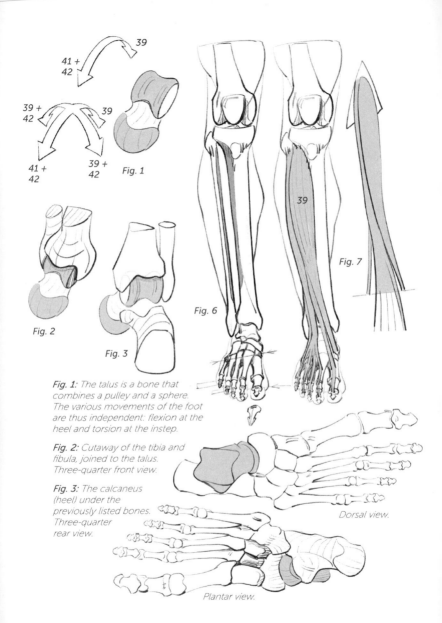

Fig. 1: The talus is a bone that combines a pulley and a sphere. The various movements of the foot are thus independent: flexion at the heel and torsion at the instep.

Fig. 2: Cutaway of the tibia and fibula, joined to the talus. Three-quarter front view.

Fig. 3: The calcaneus (heel) under the previously listed bones. Three-quarter rear view.

Dorsal view.

Plantar view.

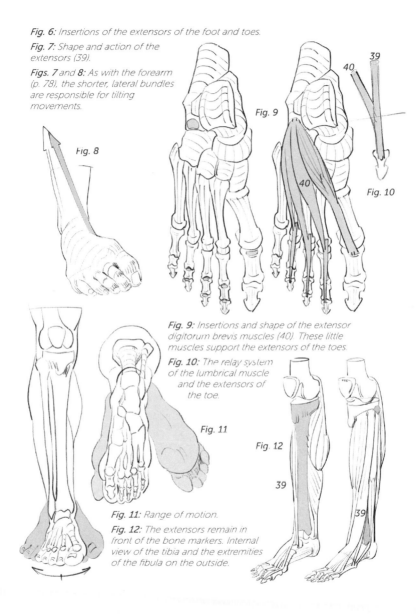

Fig. 6: Insertions of the extensors of the foot and toes.

Fig. 7: Shape and action of the extensors (39).

Figs. 7 and **8:** As with the forearm (p. 78), the shorter, lateral bundles are responsible for tilting movements.

Fig. 8

Fig. 9

40

39

40

Fig. 10

Fig. 9: Insertions and shape of the extensor digitorum brevis muscles (40). These little muscles support the extensors of the toes.

Fig. 10: The relay system of the lumbrical muscle and the extensors of the toe.

Fig. 11

Fig. 12

39

39

Fig. 11: Range of motion.

Fig. 12: The extensors remain in front of the bone markers. Internal view of the tibia and the extremities of the fibula on the outside.

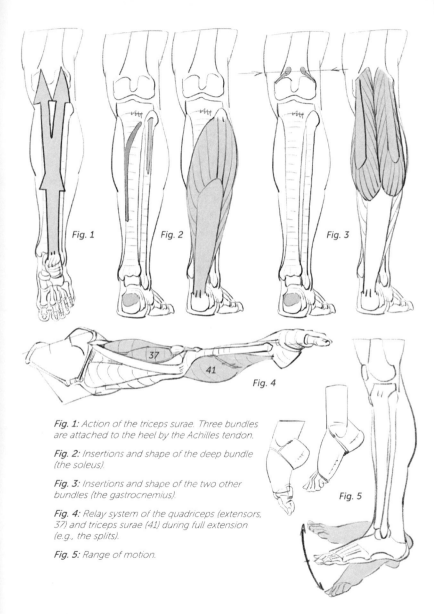

Fig. 1: Action of the triceps surae. Three bundles are attached to the heel by the Achilles tendon.

Fig. 2: Insertions and shape of the deep bundle (the soleus).

Fig. 3: Insertions and shape of the two other bundles (the gastrocnemius).

Fig. 4: Relay system of the quadriceps (extensors, 37) and triceps surae (41) during full extension (e.g., the splits).

Fig. 5: Range of motion.

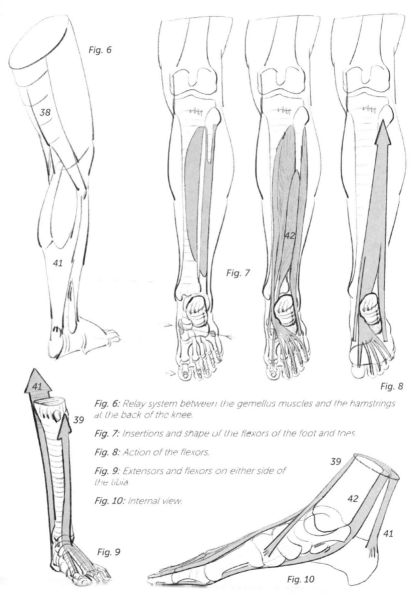

Fig. 6

Fig. 7

Fig. 8

Fig. 9

Fig. 10

Fig. 6: Relay system between the gemellus muscles and the hamstrings at the back of the knee.

Fig. 7: Insertions and shape of the flexors of the foot and toes.

Fig. 8: Action of the flexors.

Fig. 9: Extensors and flexors on either side of the tibia.

Fig. 10: Internal view.

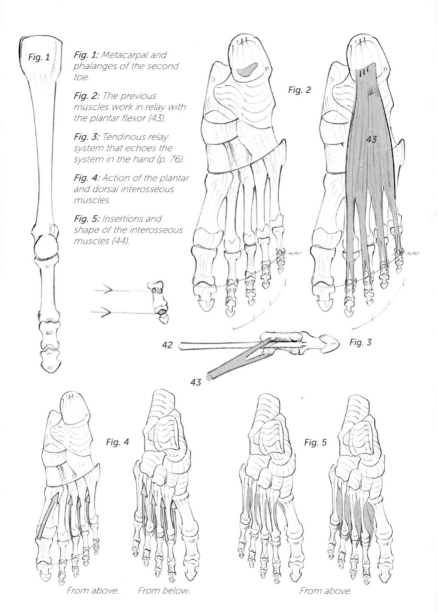

Fig. 1: Metacarpal and phalanges of the second toe.

Fig. 2: The previous muscles work in relay with the plantar flexor (43).

Fig. 3: Tendinous relay system that echoes the system in the hand (p. 76).

Fig. 4: Action of the plantar and dorsal interosseous muscles.

Fig. 5: Insertions and shape of the interosseous muscles (44).

Fig. 1

Fig. 2

43

42

43

Fig. 3

Fig. 4

Fig. 5

From above. From below.

From above.

Fig. 6: Action of the big toe adductors (45) and the little toe abductors (46).

Figs. 7 and **8:** Insertions and shape of the above-mentioned.

Fig. 9: The fat on the bottom of the foot hides and protects the musculature.

Fig. 10: These muscles stretch the plantar arch, like the string of a bow.

resources

George B. Bridgman, *The Human Machine*, Dover Publications, Inc., New York, 1972

Frederic Delavier, *Strength Training Anatomy, 3rd Edition*, Human Kinetics Publishers, Illinois, 2010

Paul Richer, *Artistic Anatomy*, Watson-Guptill, New York, 1986

Stephen Rogers Peck, *Atlas of Human Anatomy for the Artist*, Oxford University Press, New York, 1951

For French speakers (from the original French edition):

Georgette Bordier, *Anatomie appliquée à la danse*, Éditions Amphora, Paris, 1980

Alain Bouchet and Jacques Cuilleret, *Anatomie topographique et fonctionnelle*, Simep, Paris, 1983

Werner Platzer, *Atlas de poche Anatomie*, Lavoisier médecine, France, 2014

Henri Rouvière and André Delmas, *Anatomie humaine*, Paris, Masson, 1984

abbreviations

4ceps: quadriceps
abs: rectus abdominis
coc: coccyx
hum: humerus
hy: hyoid bone
isc: ischium
meta: metacarpal

pub: pubis
sacr: sacrum
sp: spine
ster: sternum
thy: thyroid cartilage
tra: trachea